SIGNALLING AND SIGNAL BOXES

Along the North British Railway, Great North of Scotland Railway and the CLC Routes

Allen Jackson

AMBERLEY

First published 2017

Amberley Publishing
The Hill, Stroud,
Gloucestershire, GL5 4EP

www.amberley-books.com

Copyright © Allen Jackson, 2017

The right of Allen Jackson to be identified as the Author
of this work has been asserted in accordance with the
Copyright, Designs and Patents Act 1988.

All rights reserved. No part of this book may be reprinted
or reproduced or utilised in any form or by any electronic,
mechanical or other means, now known or hereafter invented,
including photocopying and recording, or in any information
storage or retrieval system, without the permission in writing
from the Publishers.

ISBN: 978 1 4456 6768 3 (print)
ISBN: 978 1 4456 6769 0 (ebook)

British Library Cataloguing in Publication Data.
A catalogue record for this book is available from the British Library.

Typeset in 10pt on 13pt Celeste.
Origination by Amberley Publishing.
Printed in the UK.

Contents

Introduction 5

Signal Boxes and Infrastructure on Network Rail 6

Summary of Contents 8

Cheshire Lines Committee (CLC) 10

North British Railway (NBR) 36

Great North of Scotland Railway (GNoSR) 80

Introduction

The Cheshire Line Committee (CLC) was an unusual railway undertaking in that it had no locomotives of its own, but used those from one of its constituents, the Great Central, and the Great Northern and the Midland railways were the other partners. Most of it was in Lancashire and it gave access to the northern hub of Manchester–Liverpool for those companies who had to fight the London & North Western and the Lancashire & Yorkshire for a piece of the market. This inevitably led to the duplication of routes to some extent, followed by BR's network culling. Consequently, the CLC is a shadow of its former self and little mechanical signalling survives.

The North British Railway (NBR) proudly took the Flying Scotsman's baton on the Scottish Borders to Edinburgh Waverley station, and up the east coast of Scotland on a joint line with the Caledonian Railway to Aberdeen. As Edinburgh has been extensively modernised, not much of the NBR has survived, although the West Highland Railway retains its unique flavour.

The Great North of Scotland Railway (GNoSR) joined up the granite city of Aberdeen with the prosperous town of Elgin, and although it too suffered from branch line closures, there is enough there to record a proud individuality.

The major centres have had their signalling updated since the 1960s and so only the secondary lines and branches tend to still operate mechanical signalling. All of the East Coast Main Line has been modernised, and indeed some of it is currently being re-done, so the book – which is divided up into journeys where that is possible or desirable – follows mainly secondary and branch lines.

The system of units used in this book is the imperial system, which is what the railways themselves still use (although there has been a move to introduce metric units in the Railway Accident Investigation Branch reports and in the South East of England, where there are connections to the Channel Tunnel). Distances and quantities will have a conversion to metric units in brackets after the imperial units used.

1 mile = 1.6 km, 1 yard = 0.92 m, 1 chain = 22.01 m. 1 chain = 22 yards.
1 mile = 1760 yards or 80 chains.

Signal Boxes and Infrastructure on Network Rail

Introduction

The survey was carried out between 2003 and 2016 and represents a wide cross-section of the remaining signal boxes on Network Rail.

Inevitably, some have closed and been demolished, while others have been preserved and moved away since the survey started. The large numbers of retired or preserved signalling structures have not been considered in this work and are to be held over for a future volume. The only exception to this is in the West Highland section, where some listed signal boxes no longer in use by Network Rail have been included in order to give a true impression of the line.

Listed Buildings

Many signal boxes are considered to have architectural or historic merit and are Grade II listed by English Heritage, which means that they cannot be changed externally without permission. If the owner allows the building to decay to such an extent that it is unsafe, the building can then be demolished.

A Grade I listing would require the interiors to remain the same, so that is unlikely to happen with Network Rail structures, but it may happen with the preservation movement, many members of which have preserved a selection of interiors as fully operational, working museums.

Historic Scotland has its own Classification system, which is as follows:

- Category A for buildings of national or international architectural worth or intrinsic merit.
- Category B for buildings of regional architectural worth or intrinsic merit.
- Category C for buildings of local architectural worth or intrinsic merit.

Signal Box Official Abbreviation

Most signal boxes on Network Rail have an official abbreviation of one, two or sometimes three letters. This usually appears on all signal posts relevant to that box. Finding an abbreviation could be tricky – as there are eight signal boxes with Norton in the title, for example – until you realise that they are not unique. If it has one, the abbreviation for each box appears after the box title in this book.

Signal Box Title or Designation

In keeping with the other books in this series, the signal box title as drafted in the original Act of Parliament for the line concerned has been used. The draftee was a person who had received no state education in the earlier part of the nineteenth century, so sometimes grammar and punctuation featured in the title, and sometimes they did not.

Summary of Contents

Cheshire Lines Committee (CLC)

CHESTER to MANCHESTER
Mickle Trafford
Mouldsworth
Greenbank
Plumley West
Mobberley
Hale
Deansgate Junction
Northenden Junction

LIVERPOOL to MANCHESTER
Hunts Cross
Warrington Central
Glazebrook East Junction

North British Railway (NBR)

EDINBURGH to ABERDEEN
Cupar
Leuchars
Tay Bridge South
Arbroath
Inverkeilor
Usan
Montrose South
Montrose North

WEST HIGHLAND RAILWAY
Garelochhead
Arrochar and Tarbet
Ardlui
Crianlarich
Bridge of Orchy
Spean Bridge
Fort William Junction
Banavie

EDINBURGH to FALKIRK AREA
Carmuirs East Junction
Rosyth Dockyard

Great North of Scotland Railway (GNoSR)

ELGIN to ABERDEEN
Keith Junction
Huntly
Kennethmont
Insch
Inverurie
Dyce

HIGHLAND RAILWAY ADDITION
Clachnaharry

Cheshire Lines Committee (CLC)

The CLC was formed of the Midland, Great Central and Great Northern railways, with a one third shareholding for each. This made the CLC predominantly LNER in management but the CLC remained independent up to nationalisation. Up until the 1920s the CLC made money, but with increasing road haulage competition the CLC went into the red.

CHESTER to MANCHESTER

Fig. 1. The diagram illustrates the remains of the signal boxes and interconnecting lines of the CLC on this line.

Chester was so attractive to railway companies that it wound up with three of the Big Four post-Grouping outfits. The LNWR (LMS) was the earliest, with the Euston main line to Holyhead and the Irish Mail in 1848, and this spawned many other lines, summarily connecting the city with Liverpool and Manchester. The GWR established a presence and a joint line to Birkenhead, on the Wirral, and so the GWR reached Liverpool as well as Warrington and Crewe. The CLC had its own station at Chester Northgate but it was always a poor relation to the other two and that lack of prestige has continued today in some measure. The Great Central (LNER) bought its way into Chester and Wrexham with the purchase of the Wrexham Mold & Connah's Quay Railway and they used Chester Northgate for some of their passenger services. Chester Northgate station is now the site of a leisure centre and car park.

The presence of the CLC in a city was often denoted by the use of the sobriquet 'Central' in the title where there were other stations and companies. Manchester Central station was the CLC destination, but as a terminus was not a natural survivor in a city that is also a transport hub for a wider area. Manchester Central station is now the G-Mex exhibition centre.

Mickle Trafford (MT)

Date Built	CLC Type or Builder	No. of Levers or Panel	Ways of Working	Current Status (2015)	Listed Y/N
1969	BR London Midland Region Type 15	35	AB/TB	Active	N

Fig. 2 is a standard London Midland Region structure and we have to wait for Mouldsworth before Cheshire Lines architecture comes into view. The panel at Mickle Trafford has the Absolute Block instrument for Helsby built into the panel. The Tokenless Block instrument is separate on the block shelf. (November 2004).

Mickle Trafford is a popular commuter village for Chester. The box is on the double-track main line that leaves Chester General station and heads for Helsby Junction. This line is a forerunner of the LNWR and is worked Absolute Block from Mickle Trafford. The single track to Manchester deviates here and the box was worked Tokenless Block to Mouldsworth at the survey date. Prior to 1969, the CLC line went to Chester Northgate, but upon its closure all trains now go to Chester General (or just Chester, as it now is).

For a signal box that has steam-age ways of working, Mickle Trafford is thoroughly modern in terms of lineside signalling as there is no mechanical signalling here. The box was also the junction for the former Great Central line to Dee Marsh Junction and Shotton Steelworks. The line had been abandoned in 1984 but steel trains from Ravenscraig in Scotland were still running. This means that trains had to be routed over the Wrexham to Chester line, which had recently been made into single track. Gresford Bank was an obstacle in steam days and so it proved again. Even with up to five Class 20 locomotives, delays to trains were so great that the line from Dee Marsh Junction to Mickle Trafford was re-laid. It was eventually taken up for the last time in 1992 after steelmaking had finished at Ravenscraig.

The epicentre of CLC operations was the former Manchester Central station. Traffic towards Manchester is travelling Up.

Mickle Trafford signal box is 35 miles and 41 chains (57.15 km) from the former Manchester Central station.

Fig. 3. The main running lines from Chester to Helsby and Warrington (LNWR) are the furthest pair. The single track in the foreground is the CLC line, with Mouldsworth to the right. The severed piece of track in the middle is the GCR line to Sealand and Dee Marsh Junction, with a connection to the Chester–Helsby line, which crossed the CLC and was finally taken up in 1992. (November 2004).

Mouldsworth (MH)

Date Built	CLC Type or Builder	No. of Levers or Panel	Ways of Working	Current Status (2015)	Listed Y/N
1894	CLC 1a+	34	TB/TCB	Demolished 2006	N

Mouldsworth is a delightful village not far from the beauty spot of the Delamere Forest.

Mouldsworth had been a junction with a line to Helsby, but when the signal box at Helsby burned down, this signalled the end of this branch line in the early 2000s.

Fig. 4 shows Mouldsworth signal box with the 'Junction' qualification still on the name board. The signal box had been extensively rebuilt and it was said that the only original part of the 1894 box was the roof. Note that there are two point rods leaving the box and heading towards Chester. These are for the point lever and facing point lock for the line, which goes from single track to double track at Mouldsworth. (November 2004).

Fig. 5 is the signal box diagram at Mouldsworth and the two rods just referred to in Fig. 4 are levers 17 and 16 for the point and facing point lock respectively. The red outlines near the tracks and box icon are the platforms of Mouldsworth station and further up the layout, to the right, are two more, which are for Delamere station. The trailing crossover has its own ground frame and is released by lever 11. The crossover is 340 yards (316 m) from the box so it should theoretically be able to be worked by rod from the box itself, although the current NR standard is 250 metres. (November 2004).

Fig. 6 is the frame at Mouldsworth – or rather half of it – but since it lost its junction status, most of it is disused. Lever 11 is the ground frame unlock lever and 16 is the unlocked facing point lock. Lever 17, the point itself, is in black. The two cut-down red levers are colour light signals. (November 2004).

Fig. 7 is the block shelf at Mouldsworth. The Tokenless Block instrument is on the left (a description of how it works is below). The cut-down AB instrument on the right is the train describer for Greenbank signal box, as Mouldsworth operated Track Circuit Block (TCB) to that place. (November 2004).

Tokenless Block Operation

This system was introduced by the Western Region of BR in the 1960s to speed up the passage of trains on single lines and remove the need for physical token swapping at every block or section. Tokenless Block (TB) requires the operation and locking of signals to be handled electrically, and is therefore more suited to colour light signal operation with track circuits, although TB operation does exist in semaphore areas too. Scotland has its own variation on the TB system, with a further refinement of shunting keys in some places. Tokenless Block works as follows:

Let us suppose that a passenger train from Chester is to be passed from Mickle Trafford to Mouldsworth. The Tokenless Block instrument has three indications possible, of which only one is ever displayed at once.

1. Normal (line blocked or no permissions granted).
2. Train in Section.
3. Train Accepted.

There is an Offer button, an Accept button and a Train Arrived button at both signal box instruments.

To pass the train from Mickle Trafford to Mouldsworth, the signaller at Mickle Trafford presses the Offer button. If Mouldsworth selects Accept, this is indicated on Mouldsworth's TB instrument as Train Accepted. This status is also reflected on Mickle Trafford's TB instrument.

This action locks all the signals on the single line from Mouldsworth to Mickle Trafford at danger. In other words, a train cannot pass in the opposite direction to which this train is going unless it passes several signals at danger.

When the train has arrived in the section at Mouldsworth, the track circuits sense this and turn both TB instruments at Mickle Trafford and Mouldsworth to Train in Section.

When the train has arrived at Mouldsworth complete with tail lamp, the signaller at Mouldsworth selects Train Arrived and the instrument indications at both places revert to Normal. This operation is interlocked with any points on the route and the system is then ready to dispatch another train in either direction.

Mouldsworth signal box was 31 miles and 5 chains (50 km) from the former Manchester Central station.

Fig. 8. The typical small-scale CLC station building at Mouldsworth has survived, although in different use. Note how the colour light signal still has the feather for the defunct Helsby branch. (November 2004).

15

Greenbank (GK)

Date Built	CLC Type or Builder	No. of Levers or Panel	Ways of Working	Current Status (2015)	Listed Y/N
1969	BR London Midland Region Type 15	35	TCB/AB	Active	N

Fig. 9 and we have another Type 15 from the LMR with almost Scotrail-sized signal box labelling. The magpie on the rail is obviously *au fait* with signalling protocol, as the preceding colour light signal indicates it is safe. (October 2016).

The box is situated at Greenbank station and replaced an earlier CLC-built box when the line was converted to TCB. The station, which is now a church, is noteworthy in having a free car park, and the facility is shared with the residents of Hartford nearby.

The box now controls a length of track of about 9 miles (14.5 km) and three junctions. The junction with the WCML is still known as 'CLC Junction', nearly seventy years after the CLC ceased to exit.

Winnington is the next junction, leading to the ICI Brunner Mond chemical works, which is chiefly recognised for the invention of polythene but their principal task is the manufacture of soda ash. The town is located on the River Weaver Navigation, next to the Anderton Boat Lift.

Finally, there is a triangular junction to Sandbach and Crewe at Northwich.

Northwich station is under Greenbank's control and, as a major player in the salt industry, it also plays host to more Brunner Mond chemical works. Northwich had extensive freight yards and a late-closing steam depot, which was coded 8E under BR.

Greenbank signal box is 22 miles and 21 chains (35.83 km) from the former Manchester Central station.

Fig. 10. The station layout with a typical CLC waiting shelter on the right. The feather on the magpie's colour light signal is to control a train into the Winnington branch, which accommodates a Brunner Mond chemical works. (October 2016).

Fig. 11. The nearer leg of the triangular junction to the Winnington branch is visible in this view and the far ground signal that allows trains to exit the branch has a double caption box above it to signal a train either onto the Up line to then reverse towards Manchester, or over the crossover to the Down line for Chester, on the right-hand side. (October 2016).

Fig. 12 shows the ramp at the end of the Up platform at Greenbank station and here we have a 'Limit of Shunt' illuminated sign that signals the extent to which a train can reverse before entering the next section and going beyond the control of the signaller. These signs are usually found where the signaller can maintain the train in direct view. Note how the former oil lamp body has been converted to run an electrical supply. Oil lamps of this type would run for a week before replenishment and wick trim was necessary. In the Great Eastern book in this series, some of the now closed signal boxes were only converted to electric from oil in 2013. (October 2016).

Plumley West (PY)

Date Built	CLC Type or Builder	No. of Levers or Panel	Ways of Working	Current Status (2015)	Listed Y/N
1908	CLC 2+	26	AB	Active	N

Fig. 13. Plumley West has the distinctive CLC nameplate suspended on two iron hooks but elsewhere shows signs of modernisation with plasticised windows and a tacked-on toilet block. The rodding tunnel has been bricked up in stages as the box has lost function over the years. A piece of bullhead rail acts as the rodding tunnel lintel. (December 2015).

The industrial areas around Northwich recede into the distance as we head across rural Cheshire towards Manchester. The signal box at Plumley West is about the only mechanical signalling left on the line, and it is a haven of Absolute Block working to boot.

Plumley West signal box is 18 miles and 7 chains (29.11 km) from the former Manchester Central station.

Fig. 14. The view towards Greenbank and Chester. The trailing crossover is signalled by two track-circuited ground discs, implying that a passenger train needed to cross over here at some time. Further down the line, on the left, was the siding to the Associated Octel Company's facility. They were in the business of putting lead in petrol to improve a car engine's running qualities before the environmental cost became too high. (December 2015).

Fig. 15. This is the view in the opposite direction, about 400 yards (372 m) away from the box towards Manchester, and the location is about half a mile (0.8 km) from Plumley station. The bridge behind the bracket signal is an occupation bridge. These were built by the railway to re-unite farmer's fields that had been separated by the railway's presence. (December 2015).

Fig. 16. Plumley West has a customer in the shape of Chester-bound Northern Rail Class 142, No. 142036. (March 2015).

19

Fig. 17. Ground discs at work. The wire coming from the foreground is the connection to the lever in the signal box. This wire connects to an iron rod, with turnbuckle adjustment, which pulls a lever against the counterweight. There are two counterweights in shot and this signal must have had an extra disc on it at some point. Each counterweight is adjustable so that the ground disc's return to danger, or 'on', is positive when the lever is replaced to 'normal' in the frame.

There are three rods coming out from the point on the right. The top one is to steady the ground disc mounting base to the point sleeper. The other two operate the horizontal rods that have U-shaped slots cut into them that allow the ground disc to be operated only if the point is in the appropriate position. This form of local interlocking is known as 'detection'. Finally, the large rod nearest the camera with the angle crank on it is the point-operating rod.

There are other rods and levers connected to this point that also operate the other point in the crossover from the same lever in the signal box. Note the illuminated backlight that will be covered up by the white arm when the ground disc operates. (December 2015).

Fig. 18. The nearby Plumley station has semaphore signals in the station building gardens but the colour light signals for the tracks are controlled by Greenbank. Plumley station has won a plethora of 'Best Kept' awards since 2006 and a local man is credited with doing most of the work here and at Mobberley station. Class 142 No. 142007 is destined for Chester. (October 2016).

Mobberley (MY)

Date Built	CLC Type or Builder	No. of Levers or Panel	Ways of Working	Current Status (2015)	Listed Y/N
1886	CLC 1b+	IFS Panel	AB/TCB	Active	N

Fig. 19. Mobberley signal box is modernised to the ultimate in plastic, but the signaller keeps tubs and hanging baskets in summer to brighten the place up. (February 2006).

Passing into the Manchester commuter belt, and as it is south of Manchester that means well-heeled (if not footballer) country.

Mobberley is a delightful village and though the railway no longer possesses any semaphore signals, there are a few signals around, such as in people's gardens and at the 'Railway' pub to indicate affection for these devices.

Mobberley West signal box is 11 miles and 75 chains (19.21 km) from the former Manchester Central station.

Fig. 20. The award-winning Mobberley station with the characteristic CLC waiting shelter on the right. The station building on the left is in private hands but is well kept and maintained. The view is towards Plumley West and Chester. (February 2006).

Hale (–)

Date Built	CLC Type or Builder	No. of Levers or Panel	Ways of Working	Current Status (2015)	Listed Y/N
circa 1875	Saxby & Farmer Type 8 (CLC)	None	None	Relay Room Active	Y

Hale is into footballer country and this is the land of Gucci and Prada in the local charity shops, discarded there after wealthy owners have moved on to the latest thing. However, the elderly signal box has survived and, as a listed building, it has been put to use in housing the large numbers of relays needed for a completely track-circuited line. The relays themselves are physically large and are encased in glass. They are referred to in signaller's parlance as 'fish tanks'. Saxby & Farmer were early signalling system contractors and were innovators in the signalling world.

Hale signal box is 8 miles and 31 chains (13.5 km) from the former Manchester Central station.

Fig. 21. Hale signal box in fine condition, with the nameplate, station buildings, awnings and footbridge all preserved. (March 2015).

Fig. 22. Not only is the signal box listed at Hale, but the listing extends to the station buildings on both platforms, as well as the canopies and footbridge. The following is an extract from the listing description from Historic England: 'Waiting rooms and platform canopy. 1880s for Cheshire Lines Committee Polychrome brick with stone dressings and slate roof: cast iron canopy with glazed roof. 3-bay single- storey waiting room, 7-bay hipped roof canopy. Stone plinth and eaves band and decorative brick eaves and window impost band.'

However, the three colour light signals on view belong to Deansgate Junction, which is further up the line towards Manchester. (September 2005).

23

Fig. 23. A train from the Manchester direction is headed for Greenbank and Runcorn. The train is headed by Freightliner Heavy Haul (FHH) Class 66 No. 66525 and consists of Viridor blue recycling wagons. FHH have the largest recycling contract in the UK for Greater Manchester's waste, and the train is headed from the recycling plant near Northenden Junction to the disposal site at Runcorn. (March 2015).

Deansgate Junction (DJ)

Date Built	CLC Type or Builder	No. of Levers or Panel	Ways of Working	Current Status (2015)	Listed Y/N
1957	BR London Midland Region Type 15	Nx Panel Westinghouse	TCB	Active	N

Fig. 24. Deansgate Junction with an extension grafted onto the right-hand side to cater for the tram system controls. The barber's pole-type device on the right-hand side is to act as a warning guide to any road vehicle likely to foul the overhead catenary of the tram system. (March 2015).

Deansgate Junction is where the former line to Manchester Central carried on into the city, while another line headed off east to Northenden Junction to meet up with lines to Stockport and the Midland Railway towards Sheffield.

The Manchester Central line is now occupied by the Metro tram system, and so Deansgate Junction controls functions for the remaining double-track railway line and the tram system.

Deansgate Junction signal box is 7 miles and 6 chains (11.39 km) from the former Manchester Central station.

Fig. 25. In the general direction of Manchester, the tracks go from two to four. On the left are the twin tracks of the Manchester Metro, while on the right the line resumes double track for the 3 miles (5 km) to Northenden Junction. (March 2015).

Fig. 26. Manchester Metro tram No. 3044 bound for Altrincham, which is a tram terminus. The overhead catenary is 750 V DC. (March 2015).

Northenden Junction (NJ)

Date Built	CLC Type or Builder	No. of Levers or Panel	Ways of Working	Current Status (2015)	Listed Y/N
circa 1881	Stevens Non Standard (CLC)	25	TCB	Active	N

Fig. 27 shows Northenden Junction signal box from the Longley Lane over bridge, and it is this bridge that accounts for the height of the building. A trailing crossover is almost in front of the building and the former station and goods yard were to the left of the box. (March 2015).

Fig. 28. Some detail of Northenden Junction and of particular note is the hand-painted nameplate in typical nineteenth-century serif font style. Also noteworthy is the copious use of engineer's hard blue bricks as decoration. (March 2015).

Northenden Junction is in Gatley, a suburb of Manchester, and there was a railway station and goods yard here from the 1860s that lasted until 1964. The box has survived, however.

Stevens was an early signalling contractor and most railways employed a contractor before they had established their own signalling works. Some smaller companies never had their own works and used signalling contractors throughout their independent existence. A good deal of Stevens' equipment survives on the former Southern Railway.

Northenden Junction signal box is 33 miles and 49 chains (54.09 km) from the former Liverpool Central High Level via Glazebrook and 3 miles 72 chains (6.27 km) from Stockport Edgeley No. 2 Junction.

Fig. 29. This picture shows the lines that Northenden Junction controls and the Viridor loop, where trains like the one we saw at Hale originate from when running to the disposal site at Runcorn. The left-hand line eventually crosses under its neighbour and heads south towards New Mills Central and the Midland Railway route to Sheffield. The right-hand route heads north to join up with the LNWR route to Manchester Piccadilly at Stockport Edgeley Junction No. 2 signal box. This line also becomes single track after a while. Finally, on the right is the Viridor loop and depot. The right-hand track is arrival and departure, while the left-hand track is the Class 66 run-round loop. (March 2015).

LIVERPOOL to MANCHESTER

Fig. 30 shows a much-reduced layout and facilities, with some of it having been diverted after the final closure of Liverpool Central High Level station in 1972.

Liverpool as a major sea port was second only to London, and in 1900 it saw 27 per cent of all commerce with what is now the Commonwealth and the vast bulk of traffic to the US, Canada and South America. Any railway company worth its salt, therefore, had to have a piece of the Liverpool market.

Liverpool to Manchester had already been rail-connected by the time the CLC arrived on the scene, but the CLC managed to garner significant passenger traffic with its hourly express service. Stretches of the line were completely flat and without curvature, and this assisted the speediness of CLC expresses. An imaginative price cut saw CLC services between the cities eclipse those of the LNWR and LYR combined. The CLC locomotive shed at Brunswick, Liverpool, was an early closure casualty, but Glazebrook and Trafford Park locomotive sheds managed to soldier on until the mid-1960s, by which time they had lost their GCR/LNER locomotives.

Hunts Cross (HC)

Date Built	CLC Type or Builder	No. of Levers or Panel	Ways of Working	Current Status (2015)	Listed Y/N
1982	BR London Midland Region Power Room	Nx Panel	TCB	Active	N

Fig. 31. Hunts Cross signal box has all the charm and architectural grace of a local authority bus shelter, and was built in an era when such sensibilities were not considered as they are now. (April 2013).

The Nx panel in the signal box controls the lines to the following stations, reading from Liverpool Central station eastwards towards Manchester:

Brunswick (former CLC loco shed there)
St Michael's
Aigburth
Cressington
Garston
Hunts Cross
Halewood
Widnes Central

From Liverpool Central to Padgate near Warrington, there were fifty manual signal boxes in the day when it was all semaphore controlled, although the network was considerably larger then than it is now.

Hunts Cross signal box is 7 miles 12 chains (11.5 km) from the former Liverpool Central station.

Fig. 32. Hunts Cross station buildings and stationmaster's house survive as listed buildings, although they are no longer in railway use. Historic England describes them as a 'good example of the stations built for the Cheshire Lines Committee'. (April 2013).

Warrington Central (WC)

Date Built	CLC Type or Builder	No. of Levers or Panel	Ways of Working	Current Status (2015)	Listed Y/N
1973	BR London Midland Region Type 15	55	TCB	Active	N

Fig. 33. Warrington Central signal box, which is another stranger to be found in a book about the LNER. This was London Midland Region territory, and the box has a fifty-five-lever frame to operate switches for colour light signals and points. Warrington Central was the site of the CLC's signalling school and a Network Rail signalling presence was still there at the survey date. (December 2015).

Warrington was, and is, a considerable railway junction, lying as it does between Liverpool and Manchester and being bisected by the West Coast Main Line. Warrington also had its own industries and the 1936 film *Night Mail* had John Grierson reminding us of the 'Steelworks of Warrington'.

Warrington Central is something of a backwater compared with the drama of Scottish expresses on the LNWR West Coast Main Line at Bank Quay station.

Warrington Central signal box is 18 miles 34 chains (29.65 km) from the former Liverpool Central station.

Above: Fig. 34 is a picture of part of Warrington Central station and the canopies are reminiscent of CLC examples on the suburban stations out of Manchester (with the exception of Hale). (December 2015).

Left: Fig. 35. The monolithic station building survives in other use and it was clearly designed to make a statement about the CLC's importance. However, the station only ever had two platforms and was much less busy than Bank Quay, across town. (October 2005).

Fig. 36. 'Engraved in tablets of stone' is a popular metaphor for permanence. The CLC took this to extremes with the goods shed at Warrington Central. The stone plaque above the steel girder lintel reads 'CLC 1897'. Along the sides, the names of the Great Central, Great Northern and Midland railways are proclaimed in similarly flamboyant style. At the time of survey, builders were present to convert the goods shed into flats. A similar structure at Manchester Central goods depot wasn't as fortunate and was destroyed in the Blitz of the Second World War. (October 2005).

Glazebrook East Junction (GE)

Date Built	CLC Type or Builder	No. of Levers or Panel	Ways of Working	Current Status (2015)	Listed Y/N
1961	BR London Midland Region Type 15	80	TCB	Active	N

Glazebrook was an important junction for the CLC as it linked the Liverpool to Manchester route with a line towards Northenden Junction at Timperley, while also allowing access to the Manchester Ship Canal. All that remains is a passing loop, which would be accessed by Up trains towards Manchester by a trailing crossover and a couple of sidings and loops.

There had also been a loco depot here, which was a sub-shed to Trafford Park (coded 9E in BR days). Some remains of the loco inspection pits and tracks remained at the first survey in 2006. Glazebrook was the CLC's connection to the Manchester Ship Canal and a tortuous link to Northenden Junction, which has now been severed.

Glazebrook East Junction signal box is 24 miles and 60 chains (39.83 km) from the former Manchester Central station.

33

Fig. 37 shows a large signal box of eighty levers and this gives some idea of the tracks and facilities in the 1960s when this box was built. Some of the mechanical signalling is on display, with a ground disc for reversing into the sidings off the Down line. The coal bunker on the left still lives and the distance-marker board informs us that the box is 24¾ miles (39.83 km) from Liverpool Central. (March 2015).

Fig. 38. From the Glazebrook Lane over bridge is this view of the junction and the box. Two ground disc signals are the sum total of the mechanical signalling presence here. Note the twenty-first-century, ultra-bright LED red signal opposite the nineteenth-century ground disc of the trailing crossover. There is no signalled ability to reverse over the crossover from the Up line, by the box. (March 2015).

Fig. 39. Northern Rail Class 156 No. 156471 is headed for Liverpool on the Down line. (March 2015).

Fig. 40. An earlier view is of the listed station building at Glazebrook, which includes the 1872-dated drinking water fountain. In the nineteenth century, clean drinking water was a resource not found everywhere and was a popular gift to travellers. (March 2006).

Fig. 41 is a view of Glazebrook station, which is typical of CLC country stations on this line; Padgate and Widnes stations are similar. Note the ornate bargeboards and decorative roof slates. Glazebrook West Junction signal box is behind the camera some way up the line, on the same side as the DMU. The conductor of the Northern Rail Class 156 DMU, No. 156482, is ensuring that there are no passengers stuck in the doors before entraining and proceeding to Manchester Oxford Road station on the Up line. (March 2015).

North British Railway (NBR)

At the Grouping in 1923, the North British Railway was the largest railway company in Scotland and the fifth largest in Britain, but the Caledonian Railway was more profitable and generally had access to larger markets and industries such as Clyde shipbuilding. While the Caledonian was an extension of the LNWR's route to Carlisle, the North British was an extension of the NER route to Berwick-upon-Tweed and the east coast of Scotland. The NBR had to finance, or help finance, the Forth Railway Bridge and two versions of the Tay Bridge, which were major capital projects that were gaps in the route until bridged. Edinburgh Waverley station joins with the two bridges as the major infrastructure legacy of the North British Railway.

Major investment in Glasgow to Edinburgh and its surroundings has meant that there is virtually no mechanical signalling left. The routes are confined to the east coast towards Aberdeen and the West Highland Railway, although there were some fragments around Falkirk and Rosyth in Fifeshire.

Note: any listed signal box in Scotland has its Historic Scotland A, B or C designation appended after the 'Y' in the 'Listed' column.

FIFE to ABERDEEN

Fife was an ancient kingdom in Scotland but in more recent times has seen considerable wealth from the coalfields in the south. Additionally, it is renowned as the home of golf at St Andrews in the north. It borders the Firth of Tay to the north and one of the great railway bridges on the east coast crosses the river to Dundee. At the southern end of Fife is the Firth of Forth railway bridge – one of the most iconic railway structures in the world.

The journey begins in the south and heads across the River Tay to Montrose.

Fig. 42 shows a joint line from Edinburgh and Perth to Aberdeen, with the NBR inhabiting the southern end, the Caledonian Railway largely to the north, and with the CR dominating overall.

Cupar (CP)

Date Built	NBR Type or Builder	No. of Levers or Panel	Ways of Working	Current Status (2015)	Listed Y/N
circa 1917	North British Type 7+	32	TCB/AB	Active	N

Cupar is a former royal borough and is now an attractive market town.

The build date of the signal box is a 'guesstimate' based on the construction date of similar Type 7 boxes and the construction date of Leuchars Junction, its neighbour.

Cupar signal box is 44 miles 58 chains (71.98 km) from Edinburgh Waverley station.

37

Fig. 43 is a little unusual in that there are no railways evident. The box has been set back from the railway layout as there is a curve at one end of the station and a substantial over bridge at the other. (September 2007).

Fig. 44. This photo illustrates the northern end of the station and the box's distance from the running lines. The layout here is limited to an engineer's siding and headshunt, together with a trailing crossover. The siding could just about accommodate a tamping machine or locomotive. (September 2007).

Fig. 45 shows an unusual lattice-post elevated ground signal on the end of the Up platform, which is used to signal a reversing move over the trailing crossover. (September 2007).

Fig. 46. The station building at Cupar has won awards for its adaption as a community resource, as well as for its gardens. It dates from 1847. (September 2007).

Fig. 47 shows the Up starter signal for Edinburgh and part of the magnificent stone over bridge. Note the pinkish-coloured granite ballast, which is commonplace north of the border. (September 2007).

Leuchars (LE)

Date Built	NBR Type or Builder	No. of Levers or Panel	Ways of Working	Current Status (2015)	Listed Y/N
1920	North British Type 8	38	AB	Active	N

Leuchars was the station for RAF Leuchars for many years, a fighter base designed to repel the threat from Soviet bombers in the Cold War. It is also now the station for St Andrews.

Fig. 48 shows Leuchars signal box as a building larger than its current thirty-eight levers would suggest, and this was just the north signal box! Note the LNER concrete hut over the tracks. (September 2007).

Fig. 49 depicts the north end of Leuchars station and five ground signals mostly relating to the Down sidings on the left. The tracks diverge here to go around the island platform. The rusty track outside the box leads to a loop and siding, which is termed Out Of Use (OOU) on TrackMaps. (September 2007).

41

Fig. 50 is another elevated ground disc signal – this time a double – with access to the crossover at the north end of the station and the loop and siding right by the signal box also being visible. The island platform can be seen and at one time this had two bays to accommodate the two passenger trains from the branch lines. The view is towards Dundee and the box is on the right. (September 2007).

Leuchars Junction was formed by the input of two more lines. A line ran through Tayport, which rejoined the main line to cross the Tay Bridge, and there was also a line running south along the Fifeshire coast to eventually rejoin the main line at Thornton Junction, near Dunfermline.

Leuchars signal box is 50 miles 79 chains (82.1 km) from Edinburgh Waverley station.

Tay Bridge South (TS)

Date Built	NBR Type or Builder	No. of Levers or Panel	Ways of Working	Current Status (2015)	Listed Y/N
1887	North British Type 2a	27	AB/TCB	Active	N

The Tay Bridge has had a chequered career. The first incarnation fell down in a gale with a train on the bridge on the night of 31 December 1879; seventy-nine souls perished and there were no survivors. The fateful train was signalled onto the Tay Bridge as the vital Absolute Block (AB) signalling wiring remained intact, although it was thought that some of the bridge had collapsed before the train arrived. Sir Thomas Bouch, the original bridge's designer, had been knighted by Queen Victoria and she herself had travelled over the

Fig. 51. Tay Bridge South signal box postdates the rebuilding of the Tay Bridge, and stands guard over the bridge's southern Fifeshire shore. There is no longer any AB working between the box and Dundee. (September 2007).

Fig. 52. The piers of the original Tay Bridge that played a part in the disaster of 1879 are prominent here on the south bank, looking across to Dundee. There is said to be a horse and cart and driver entombed below the water line in one of the piers as a result of an accident at the time of the original bridge's construction. (September 2007).

Fig. 53. The rebuilt Tay Bridge from the south shore. The high girders where the passenger train came to grief in 1879 on the original bridge can be seen over towards the Dundee shore, which were necessary to allow ships to pass underneath. (September 2007).

bridge some time before its collapse. Sir Thomas was due to design the Forth Bridge, but after the disaster had withdrawn from engineering. The eventual designer, understandably, considerably over-engineered the Forth Bridge to produce the structure that everyone is familiar with today.

Tay Bridge South signal box is 56 miles 36 chains (90.85 km) from Edinburgh Waverley station.

Arbroath (AH)

Date Built	NBR Type or Builder	No. of Levers or Panel	Ways of Working	Current Status (2015)	Listed Y/N
1911	North British Type 7+	72	AB/TCB	Active	Y 'B'

Fig. 54 is the refurbished Arbroath signal box and some of the windows have been plated over. The box is still called Arbroath North but now controls the whole layout. The signal box was built the same time as the station, in 1911, and a large tablet of stone on the excellent station building proclaims this. There are still plenty of points that are rod-worked here at the survey date, including the facing point locked example outside the box. (September 2007).

Fig. 55. The line towards Montrose curves away and the bracket signal at the station throat has at least two signal arms motor operated. The Up north sidings on the right are slowly disappearing in the undergrowth, and there are eight ground disc signals in view. Note how the ends of check rails on the training crossover are painted white to act as an aid at night. (September 2007).

44

Fig. 56. Drawing back from the previous photo on the platform, the ornate cast-iron footbridge behind the box can be seen, which allows street pedestrians to continue their journey even when the barriers are down. The goods yard is on the left and the goods shed can just be seen. The triple-decker ground disc signals a route from the goods yard of either the Down main line towards Montrose, facing crossover to the Up main line, or facing crossover to the Up north sidings. (September 2007).

Fig. 57 shows the fine platform level buildings and splendid canopy ironwork. (September 2007).

Fig. 58 is the view on the same platform towards the Up direction, which leads to Edinburgh. The station building ticket office is mounted at street level above the platforms and the girders are supporting the station building at the upper level. Note the cut-down lattice-post starter signal. On the far side the track for a third platform can just be seen, which used to house trains terminating at Arbroath from Dundee and Perth. The trains now terminate at Carnoustie and this track has now been removed. Kerr's Miniature Railway is some way up past the end of platform 1, where the camera is. (September 2007).

45

We are past Dundee now and into the county of Angus, travelling up the east coast to Arbroath, which is most famous for Arbroath Smokies – a particular type of smoked haddock. The brand name is protected by the EU in the same way as Champagne and Parma ham is.

Certainly famous with railway fans is Kerr's Miniature Railway, which runs along the beach parallel to the ECML. There are humorous pictures of A1 Pacific locomotives and trains on the ECML apparently racing one of Kerr's locomotives in the 1950s.

Arbroath signal box is 16 miles 60 chains (26.96 km) from the former Dundee Tay Bridge station.

Fig. 59. The platform 3 track just referred to can easily be seen in this shot, taken level with the station building. To see a goods yard complete with crane in the twenty-first century is extraordinary and, as this was a source of traffic for the line, it certainly merits inclusion. Fish from the Solway Firth on the GSWR was carried by rail until 1982 and perhaps it was the case here that Arbroath Smokies left this yard long after conventional variable wagon freight trains had ceased to run. The yard and shed were demolished in November 2008. (September 2007).

Fig. 60. Kerr's Miniature Railway provides the second of the two signal boxes in Arbroath. The line is equipped with some signals, but not Absolute Block working. The ECML is in the background and this is near the site of the popular photographs of the 1950s. (September 2007).

Inverkeilor (IR)

Date Built	NBR Type or Builder	No. of Levers or Panel	Ways of Working	Current Status (2015)	Listed Y/N
1881	North British Type 1	22	AB	Active	N

Right: Fig. 61. Inverkeilor signal box appears to be quite small but there is a considerable admin extension on the rear. There is a trailing crossover, refuge siding on the Down side and an engineer's siding. The engineer's siding is behind the box and the track is just visible by the stone loading dock. The shed on the right is a typical railway-type edifice that may have held firewood or was possibly the lamp room. These were often built from old sleepers. (September 2007).

Below: Fig. 62. The engineer's siding shows up better in this view towards Edinburgh. The refuge siding is off the same crossover as the engineer's siding by the lattice-post signal. (September 2007).

47

Fig. 63. Under the shadow of signal IK 6, opposite the box, is the view Down towards Montrose. (September 2007).

Fig. 64. Signal IK 6 and the box is switched out as all visible signals are 'OFF'. (September 2007).

There once was a station and goods yard here to service the village of Inverkeilor, but they are long gone due to the LNER closure programme in 1930.

Inverkeilor signal box is 23 miles 10 chains (37.22 km) from the former Dundee Tay Bridge station.

Usan (US)

Date Built	NBR Type or Builder	No. of Levers or Panel	Ways of Working	Current Status (2015)	Listed Y/N
1906	North British Non Standard	16	AB/TB	Demolished	N

The line northwards from Dundee had originally been single track with passing places. Subsequently, however, the line was doubled up to and including Usan, and the line then

Fig. 65. Usan signal box was extensively modernised in 2005 and the investment had only five years to realise its worth. (September 2007).

passed over two single-track viaducts – the Rossie and the South Esk over the North and South Esk Rivers – before reaching Montrose station. The line from Usan to Montrose has remained single track and is the only track as such between Kings Cross and Aberdeen.

The line was re-signalled in 2010 and both Usan and Montrose South signal boxes were demolished in the process, with the section between them being converted from Tokenless Block to Track Circuit Block.

Scottish Tokenless Block System

The principle of operation is the same as we have seen in England, insomuch that the Scottish Tokenless Block is also a way of speeding up operation on single lines by avoiding trains having to stop to exchange tokens. Tokenless Block usually involves special, interlocking instruments that ensure that conflicting moves cannot be set up on single lines, but from Usan to Montrose South it was achieved by switches and levers. Certain variants of STB on the Glasgow & South Western section had shunting keys, but there were no shunting keys at Usan.

Before the passage of a train can begin, both signallers must ensure that any previous train must have sent or received Train Out of Section from both boxes.

For the sake of the example we will assume that the train is leaving Usan for Montrose South. The text in bold indicates a signal box that has instigated an action.

RK Ringing Key at Usan is an AB instrument bottom section
AS Acceptance Switch
Ack Acknowledge

From Usan	To Montrose South	Note
Call attention RK	Ack call attention RK	
Line Clear? RK (bell code)	Ack Line Clear RK (bell code)	Montrose South select R for Reverse on AS
RK hold 5 secs	Train Coming From (indication)	Opposite direction signals locked
	RK hold 5 secs	
Train Going To (indication)		Usan can clear signals
Train Entering Section	Ack Train Entering Section	
	Call attention RK	When Montrose South sees Tail Lamp
Ack Call attention	Set AS to Normal	
	Train Out of Section RK	
Ack TOS RK 5 secs		Restores the locking to Normal

Fig. 66. This vista is north of the two viaducts and the single line to Montrose South signal box. (September 2007).

An incident occurred involving Usan signal box in October 1975. A Class 47 and eleven air-braked coaches were heading for Kings Cross from Aberdeen when the locomotive failed completely on the Up line towards Inverkeilor some way past Usan signal box. Assistance was summoned and a Class 40 locomotive was sent south from Montrose and arrived at Usan where, because the track circuits sensed the stranded train's presence, the signaller was unable to pull off the section signal (lever 10 in the frame). The signaller green-flagged the locomotive past the box and on to the section. Although the guard had placed detonators behind the train, the Class 40 was travelling too fast to stop in time after the stranded train had been sighted and the resulting collision killed one young woman and injured about forty passengers and crew. The actual miles and chains of the Class 47 and train had been wrongly reported and the Class 40 driver was under the impression that there was still some way to go.

Usan signal box was 28 miles 48 chains (46.03 km) from the former Dundee Tay Bridge station.

Fig. 67. Inside the box at Usan and the diagram layout clearly shows the point at which the line goes to single track. From the differing colours, we can see it is all track circuited. The AB instrument for Inverkeilor (Arbroath if Inverkeilor is switched out) is on the left and the signaller has given Line Clear for a train from the south but, as we can see from the lack of track circuit lights, it is not in Usan's section yet. The south signaller would have given two bells for Train Entering Section before any lights would have shown. The box with the winding handle is a Welwyn Control release delay, where a track circuit failure can be overcome, but a delay is built in by means of the cranked handle. Lever 1 in the frame is the Tokenless Block acceptance lever and the rest of the levers are:

a. Up colour light distant and home, which are levers 4 and 5 from Inverkeilor.
b. Lever 7 is the junction point and lever 9 is its facing point lock.
c. Lever 8 is a form of trap point but is separately worked.
d. Levers 10 and 12 are Up home signals towards Inverkeilor and Dundee.
e. Lever 13 is the Up line colour light distant.

The rest of the frame is spare white. As there is no TB instrument here, there is no built-in bellcode ringer, so an AB instrument bottom is placed on the right-hand side of the block shelf. This is the instrument referred to in the TB description. The number of telephones is astonishing; perhaps this box was an emergency Mission Control if Houston was not available. (September 2007).

52

Fig. 68. Beyond the frame on the front wall of the signal box are two stirrup levers, which are the detonator placer devices. Detonator placer levers are often levers within a frame but their use has been deemed hazardous. Therefore, even though detonators are still used, placer devices are not. (September 2007).

Montrose South (MS)

Date Built	NBR Type or Builder	No. of Levers or Panel	Ways of Working	Current Status (2015)	Listed Y/N
1881	North British Type 1+	42	TB/AB	Demolished	N

Montrose is a charming seaside resort and market town in a very pretty location at the mouth of the River South Esk.

Montrose South signal box was 30 miles 37 chains (49.02 km) from the former Dundee Tay Bridge station.

Fig. 69 shows Montrose South signal box in fine condition and although it has been heavily modernised with a corrugated roof, it is recognisably from the Victorian era. The bullhead track in the foreground reinforces this impression. (September 2007).

53

Fig. 70 is a view of a good deal of Montrose South's tracks and signals. The single line comes over the South Esk Viaduct and fans out to double track, which is the clean-ballasted section. There is a goods yard consisting of a loop line nearest the Up main line towards Dundee, as well as five sidings and a headshunt. The bracket signal showing home and distant 'OFF' also had a subsidiary signal to control entry to the Down through siding, which was actually a loop. The home and distant on the viaduct also signal the Down main line to Montrose North. (September 2007).

Fig. 71. The end of the platforms at Montrose station and the loop line is still in position on the far side of the platforms despite having lost its entry signal. The bracket signal also signals entry into the goods loop. (September 2007).

Montrose North (MN)

Date Built	NBR Type or Builder	No. of Levers or Panel	Ways of Working	Current Status (2015)	Listed Y/N
1881	North British Type 1	51	AB	Active	Y 'C'

North of here, towards Aberdeen, the signalling is of Caledonian Railway origin.

Montrose North signal box is 30 miles 69 chains (49.67 km) from the former Dundee Tay Bridge station.

Fig. 72. Montrose North has not enjoyed as much modernisation as the south signal box and retains its slate roof as a listed building. It had been switched out for many years but now controls the TCB section from Inverkeilor. The concrete raft on the right of the box is evidence of a TCB relay room or some such being constructed. However, it was to be another three years from the photograph date before Montrose North was fully operational and took over the work of Usan and Montrose South signal boxes. (September 2007).

Fig. 73 is a look back along the line at Montrose to the South Esk Viaduct. The signal in the foreground appears to have a motor but no arm. Clearly the signalling at Montrose North was a 'work in progress' at the survey date. (September 2007).

55

West Highland Railway

The West Highland line is held in great affection by enthusiasts and the stirring record of its epic construction has been written about by John Thomas, which was published by David & Charles. The line is currently home to the Jacobite heritage steam trains journeying from Fort William to Mallaig.

The approach here has been to include a few of the preserved, listed signal boxes, as well as active Network Rail ones. This is to provide a bit of the flavour of the line rather than just cover its northern extremities. The not-to-scale diagram at Fig. 74 is a representative selection of the boxes on the line as nearly all the former West Highland signal boxes have been listed and are preserved in situ. The exception is Annat gate box, located just along the Mallaig line from Banavie, which was closed and demolished. Most stations that are passing places still have ground frames that locally operate sidings, whereas the passing loops themselves are spring-loaded and have been set for the loop direction required, which is usually the left-hand side. A train proceeding in the trailing direction is able to force the blades open against the spring, whereupon they resume their original facing pre-selection.

Fig. 74. The North British Railway to West Highland Line.

56

The reason so many signal boxes have been closed is that an updated method of single-line operation has been employed, which does away with swapping physical tokens. It was pioneered in Scotland on the far north line after inclement weather had swept away 40 miles (64 km) of telegraph poles carrying the electric token cabling.

Radio Electronic Token Block (RETB) Operation

In the Victorian method of token operation, a physical token is issued to the train driver that is specific to that section of track. That token acts as the driver's authority to proceed on that section of track and no other. When the train arrives at the end of the section for which the token is valid, the token must be surrendered and another token issued that is valid for the next section of track. It is the driver's responsibility to ensure that the correct token for the line being travelled on has been issued. Tokens are frequently fitted with an Annett's key, which enables the train driver to unlock ground frames and change points on lightly used lines. A token removed from the machine locks all opposing signals and another token in the opposite direction is issued.

RETB is an update to the nineteenth-century system wherein the controlling signal box, in our case Banavie, issues a radio signal from the box that is displayed in the train driver's cab as the 'token' for that section of track. The train driver has to press a button to acknowledge receipt of the electronic token and this is relayed back to the signal box. The section of track authorised is displayed in the cab electronically. Once the train driver has acknowledged receipt of the token, the signaller gives verbal permission over the radio to pass a STOP board, and the train then enters the section for which permission has been granted and a token issued. In place of the signal register, there is voice-recording equipment instead.

Garelochhead (–)

Date Built	NBR Type or Builder	No. of Levers or Panel	Ways of Working	Current Status (2015)	Listed Y/N
1894	North British Type 6	–	–	Closed	Y 'B'

Into the county of Argyle and Bute and the town is associated with the nuclear submarine base situated on the Gare Loch, which is a large and deep inlet on the west coast.

West Highland stations often consisted of an island platform that contained the station building and signal box, which is the case here.

Garelochhead station is 8 miles and 76 chains (14.4 km) from Craigendoran Junction, near Glasgow.

Fig. 75 shows all three buildings, where the third is the goods shed to the left. The shed's rail loading bay faces one of the platform lines and an engineer's siding is in front of the shed. The view is towards Fort William. (September 2003).

Fig. 76. The view further towards Fort William has the RETB mast on the left, near the transit van. The trap point for the engineer's siding, heading off into the undergrowth, is also located there. The 9 mile (14.48 km) post is on the right. (September 2003).

Arrochar & Tarbet (–)

Date Built	NBR Type or Builder	No. of Levers or Panel	Ways of Working	Current Status (2015)	Listed Y/N
1894	North British Type 6	–	–	Closed	Y 'B'

Fig. 77. Scotrail DMU Class 156 No. 156449 departs from the far left-hand platform of the island to Glasgow Queen Street station. The 'STOP' boards referred to in the introduction are visible and there are additional blue lights, which are part of the European Railway Traffic Management System (ERTMS). These, if passed inappropriately, will automatically bring the train to a standstill.

The signal box is now a waiting room. Many of the stations nearer Glasgow are built up from road level and, consequently, are accessed by a subway – the parapet and iron railings of which can be seen on the left. (November 2015).

Fig. 78. At an earlier survey date, the engineer's sidings were in use for loading felled pine trees, which were probably bound for Corpach paper mill near Banavie, which is further north up the line. (September 2003).

The station stands between the villages of Arrochar and Tarbet, and is popular with walkers and tourists.

Arrochar & Tarbet station is 19 miles and 45 chains (31.48 km) from Craigendoran Junction, near Glasgow.

Ardlui (–)

Date Built	NBR Type or Builder	No. of Levers or Panel	Ways of Working	Current Status (2015)	Listed Y/N
1894	North British Type 6	–	–	Closed	Y 'B'

Fig. 79. The signal box at Ardlui is now a waiting room for passengers and this view towards Glasgow shows the engineer's sidings. By the first point is a ground frame that controls the siding's entry. (September 2003).

Fig. 80. The ground frame three-lever frame has, from left to right: a facing point lock lever and the FPL itself is on the right on the track bed; a release locking lever to enable the ground frame; and a point lever for the point, which is also on the right. (November 2015).

Ardlui village is popular with tourists, and is situated at the head of Loch Lomond.

Ardlui station is 27 miles and 43 chains (44.32 km) from Craigendoran Junction, near Glasgow.

Fig. 81. The ground frame diagram illustrates the frame, point with FPL and trap point. (November 2015).

Fig. 82. The operation is outlined on the lead plates of the levers: a) Insert Annett's key in the lock in the box marked 'A' and pull over lever 2; b) Unlock the point by reversing lever 1; c) Change the point and trap point over by reversing lever; d) Replace the lock by setting lever 1 to normal. (November 2015).

Crianlarich Upper (–)

Date Built	NBR Type or Builder	No. of Levers or Panel	Ways of Working	Current Status (2015)	Listed Y/N
1894	North British Type 6	–	–	Closed	Y 'B'

Fig. 83. The signal box doesn't have any use at present and the celebrated café in the station building was closed at the survey date. (November 2015).

Crianlarich retains its loco shed and there are two ground frames here, one for each side of the loop line. The station name board has both English and Gaelic versions.

Crianlarich station is 36 miles and 23 chains (58.4 km) from Craigendoran Junction, near Glasgow.

Fig. 84 is a closer view of the signalling arrangements at Crianlarich. The 'STOP' boards are in evidence again at the end of the loop but there is a complication here. Originally, the LMS line to Oban called at Crianlarich Lower station on a separate line. The only way the Oban line could survive was to share the line from Glasgow and then reach Oban by way of a new junction from the former LNER metals, which is about 40 miles (64 km) from Crianlarich. The proper sense of LMSR and LNER separation is resumed a little way out of Crianlarich at Tyndrum Upper (LNER, NBR) and Tyndrum Lower (LMSR).

The loop is bi-directionally signalled as usual but there is the added complication of a choice of line to either Oban or Fort William. The train driver has to press one of the buttons labelled on the panel to choose which destination from which platform. (November 2015).

Fig. 85. The Up loop is towards Glasgow, so this would be pressed if the train was standing on the right-hand side of the loop as the camera looks at it. If the train was going to Fort William then it would be the far right-hand button that would be pressed. The signaller then gives the token for the route, but only after the junction point has been changed by the signaller at Banavie. This is reflected on the Points Set light and theatre route indicator by the letter 'M' or 'B', where 'M' is main for Fort William and 'B' is branch for Oban.

The more usual button to be pressed for Fort William would be the second from left, with Oban being the far left-hand button. Note the two metal grids in between the track. These are Train Protection and Warning System (TPWS) 'toast racks' that would issue commands to locomotives or DMUs passing over them in adverse circumstances. There are also two ground frames here for the local sidings. (November 2015).

Fig. 86. This view is towards the junction with the Oban line. The running line has split into two for the island platform, which is in the centre of the picture. The Down sidings are to the left and the Up are on the right, which has the loco depot that is now used for permanent way purposes. (November 2015).

Bridge of Orchy (–)

Date Built	NBR Type or Builder	No. of Levers or Panel	Ways of Working	Current Status (2015)	Listed Y/N
1894	North British Type 6	–	–	Closed	Y 'B'

Into the central Highlands now and the empty vastness of Rannoch Moor is up ahead. Some of the mountains hereabouts are part of the 'Munros'; in any case, there is snow on some of them.

Bridge of Orchy station is 48 miles and 68 chains (78.62 km) from Craigendoran Junction, near Glasgow.

Fig. 87. The island platform is accompanied by the Up refuge siding and engineer's siding, which are to its left and right respectively. (November 2015).

65

Fig. 88. The ground frame with the central lever 2, showing the brown flap opened for the insertion of the Annett's key. (November 2015).

Spean Bridge (–)

Date Built	NBR Type or Builder	No. of Levers or Panel	Ways of Working	Current Status (2015)	Listed Y/N
1949	LNER Type 15	–	–	Closed Greenhouse	Y 'B'

Upon entering the Highland region, the railway has just crossed Rannoch Moor, which is one of the wildest and loneliest places in Britain. It presented McAlpine's (the contractors) with similar problems to that encountered at Chat Moss in the early days, pre-LNWR, except that the conditions were much more demanding.

Spean Bridge had been the junction for the short-lived Invergarry & Fort Augustus Railway that meandered up the Caledonian Canal route towards Inverness.

Spean Bridge station is 90 miles and 56 chains (145.97 km) from Craigendoran Junction near Glasgow.

Fig. 89. Spean Bridge is well maintained and smart looking. The Swiss chalet-style of architecture on the station building shows up well here and many stations on the line are similar. There are two separate platforms here, rather than the West Highland central island. (November 2015).

Fig. 90. Spean Bridge station seen from the footbridge. The camera is pointing towards Glasgow. (November 2015).

Fort William Junction (FW)

Date Built	NBR Type or Builder	No. of Levers or Panel	Ways of Working	Current Status (2015)	Listed Y/N
circa 1894	North British Type 6b	30	RETB/TCB	Active	N

Fort William is an oasis in a wild and sparsely populated landscape dominated by Ben Nevis, which is near the town.

The railway has been a godsend to Fort William and now the tourists flock to the Mallaig line for the Jacobite railtours, which usually feature a steam locomotive. The approach here will be to consider the railway from its outer suburbs, so to speak, at Rio Tinto Aluminium, before moving on to the junction, the station and environs, and then finally the branch to Banavie on the Mallaig line.

Fort William Junction signal box is 98 miles and 68 chains (159.1 km) from Craigendoran Junction, near Glasgow.

Fig. 91 shows Fort William signal box framed by a lattice-post signal. The Mallaig branch is in the foreground and the main line from Spean Bridge and Glasgow are in the background. On the right is the actual junction and the continuation of the single line into Fort William station. (November 2015).

Fig. 92 is the view less than half a mile (0.8 km) from Fort William signal box, and is the junction for the Rio Tinto Aluminium works. Beyond the signal is Spean Bridge and the RETB way of working. The works entry is on the left, which is signalled by the elevated ground disc signal and switched by a ground frame. Instead of a conventional trap point, we have a crossover operated in concert. Note the rodding in the foreground diving under the main line to operate the works' trap point part of the crossover. (November 2015).

69

Fig. 93. A wagon waits to be collected inside the works siding at Rio Tinto. In the days of block bulk trains, this makes it seem like the age of the pick-up goods train is not completely over. Note the ground signal to exit Rio Tinto's complex and the track on the left is for the bulk alumina discharge pad. (November 2015).

Fig. 94. The main line to Spean Bridge is on the right in this view and the branch to Mallaig on the left, which seems odd as the branch is double track, at least for a short distance. The point by the box is for a line that joins up with a series of storage loops that we shall see on our return from Fort William station. The line on the left, with a trap point, leads to the West Highland Oil (BP) pair of sidings. (November 2015).

Fig. 95. Reversing back to the next bridge produces this view of Mallaig Junction, the oil sidings and a tall bracket signal for the main line and branch line. Note the smoke-blackened staining on the near girder bridge as a memento of the steam age. Having said that, this line still sees steam engines, albeit mostly on the Mallaig branch. (November 2015).

Fig. 96. The camera rotates through 180 degrees and travels over the Nevis Viaduct to arrive at Fort William station. Class 67 No. 67011, a sleeper train, had arrived at platform 1 on the right. The Class 67 has now run round its train and reversed the train into platform 2. (November 2015).

Fig. 97. At the end of platform 1 is the release crossover and ground frame needed to achieve the run round. This is done as follows: the driver obtains permission from the Fort William signaller for a crossover on the striped telephone box on the left; the driver then holds the button in at the same time as pulling over the blue/brown locking lever; pulling the black lever reverses the points. A similar procedure is then needed to restore the crossover to normal.

Note the former MotorRail ramp on the left. This was an ill-fated venture by BR who sought to save long car journeys for motorists by offering a drive-on drive-off facility on specially adapted flat wagons, which were coupled to passenger coaches and a locomotive. (November 2015).

Fig. 98 is the view from the footbridge that was provided for the aluminium works' employees to get to work. It is back towards Mallaig Junction, but seen from the direction of the Mallaig branch. The two lattice-post signals in Fig. 94 are on view together with one end and roof of the signal box by the blue sign for McConecy's Tyre & Exhaust Centre on Inverness Road.

The double track of the Mallaig branch quickly goes to single, which is protected by the lattice-post signal, and the loops mentioned in Fig. 94 are clearly visible on the left. The loops seem to only be able to house a two-car DMU or similar and are therefore unsuitable for modern freight trains. (November 2015).

Fig. 99 is the diametrically opposite view from Fig. 98 on the same footbridge and looking towards Mallaig, whose track is on the left. The tracks on the right lead to a goods yard, loco depot and turntable. The yard points all have manual levers. (November 2015).

Banavie SC (B)

Date Built	NBR Type or Builder	No. of Levers or Panel	Ways of Working	Current Status (2015)	Listed Y/N
1987	BR Scottish Region Non Standard	VDU Workstation, IFS Panel	RETB	Active	N

73

Fig. 100. Banavie signalling centre is on the platform at Banavie station, which is closely followed by the swing bridge. (November 2015).

Banavie had a branch line extension from Banavie Junction to Banavie Pier on the Caledonian Canal before the branch line to Mallaig was built. The station at Banavie Pier still exists despite there being no passengers since its closure in 1939.

A short distance further on from Banavie Junction is the present Banavie station and signal box. Banavie is the signalling centre for the RETB system for the whole line. It was established here as there had to be a presence at the signal box to operate the railway bridge over the Caledonian Canal, so it made economic sense to combine the two functions.

The mileage changes here and Banavie signalling centre is 26 chains (0.52 km) from the former Banavie Junction. This adds up to about 2 miles (3.2 km) from Fort William station.

Fig. 101 is the business end of the swing bridge from the public walkway across the railway line. The bridge locking mechanism resembles a facing point lock. Note the hydro-electric pipes coming down the hillside to the aluminium works and Ben Nevis itself. (November 2015).

EDINBURGH to FALKIRK AREA

The Edinburgh to Glasgow lines meet up here in order to head north, first to Stirling and then to Perth. The pivotal point where this takes place is the Carmuirs Junction, where the CR and NBR meet and lead north to Larbert.

Fig. 102 illustrates the triangle of lines just described but the scale is compacted somewhat to include a lone survivor in south Fifeshire. Along from Edinburgh and across the Firth of Forth Bridge is the former Royal Naval Dockyard at Rosyth, which is now owned by Babcock Marine. As the railway is no longer needed, Rosyth Dockyard signal box has survived as a listed building.

75

Fig. 102. Falkirk and Rosyth Area.

Carmuirs East Junction (CEJ)

Date Built	NBR Type or Builder	No. of Levers or Panel	Ways of Working	Current Status (2015)	Listed Y/N
1882	North British Type 4+	28	TCB	Active	N

The main line running semaphore signals were removed the week before the survey date and most ended up at the preserved Strathspey Railway. However, the box has taken over the responsibility for the former CR box at Carmuirs West Junction. This minor triumph over the CR is likely to be short-lived as the area is to due be subsumed into the Edinburgh area signalling centre.

Carmuirs East Junction is 40 chains (0.8 km) from the NB/CR boundary.

Fig. 103. Carmuirs East Junction still has ground signals outside the box. The station seen through the bridge is Camelon. (September 2007).

Fig. 104. Carmuirs East Junction minus its semaphore signals. The view is towards Edinburgh and the curving tracks lead to Larbert Junction and onwards to Stirling. (September 2007).

Rosyth Dockyard (–)

Date Built	NBR Type or Builder	No. of Levers or Panel	Ways of Working	Current Status (2015)	Listed Y/N
1917	North British Type 7	45	–	Closed	Y 'B'

HM Royal Dockyard at Rosyth was, for many years, a major site for the refitting of surface ships and submarines for the Royal Navy. The dockyard is now the final assembly site for the Queen Elizabeth aircraft carriers. Previously, there had been a two-platform station to transport dock workers.

Rosyth Dockyard signal box is 1 mile and 21 chains (2.03 km) from Inverkeithing South Junction.

Fig. 105 is Rosyth Dockyard signal box in splendid isolation from the rest of Network Rail. Although there was some track and signalling around at the survey date, the connection with NR was disused. It is unusual in that it is of timber construction and the equipment remains in the box. It is said to be deteriorating in its external condition, losing weatherboarding and gaining broken windowpanes since the survey pictures were taken. (September 2007).

Fig. 106 depicts a lattice-post signal in fairly good condition, minus its elevated ground disc. Some track remained in the yard and there were bullhead rail chairs inscribed with LNER, LMSR and SR in situ. The iconic Firth of Forth railway bridge and the road bridge form a backdrop. (September 2007).

Fig. 107 shows a motorised semaphore that would seem to signal the end of the dockyard tracks and the start of Network Rail metals towards Inverkeithing. The dockyard had its own locomotives and engine shed. (September 2007).

79

Great North of Scotland Railway (GNoSR)

At the Grouping in 1923, the Great North of Scotland Railway was one of the smallest railway companies in Scotland with a total of just 333 miles of track. The system covered Aberdeenshire, Morayshire and Banffshire, with excursions into Inverness-shire and Kincardineshire. It shared its major route from Aberdeen to Inverness with the Highland Railway, and much else besides.

The main freight traffic was North Sea fish and Scotch whisky, with grain and seed potatoes in addition. Because of its remoteness and low passenger numbers, the system easily fell prey to closure and the only GNoSR signalling presence – preserved railways excepted – is on the line from Elgin to Aberdeen. It is mostly single track, as seen in Fig. 108, and the line is worked Tokenless Block on the single-track sections.

Fig. 108. The GNoSR from Elgin to Aberdeen.

For the Scottish Tokenless Block system, a full description and example of train handling is given under Usan signal box in the NBR section of the book.

Keith Junction (KJ)

Date Built	GNoSR Type or Builder	No. of Levers or Panel	Ways of Working	Current Status (2015)	Listed Y/N
1905	GNoS Type 7	40	TB	Active	N

Keith is a small town in the county of Moray. Keith Junction had a total of five lines feeding into it, two of which were Highland Railway. Keith had a town station and that line is now preserved as part of the Keith & Dufftown Railway, where part of the destination is a whisky distillery.

Speaking of whisky, part of the goods yard facilities at Keith were given over to the Chivas Regal distillery, but it didn't appear to be in regular use at the survey date.

Keith Junction signal box is 53 miles and 5 chains (85.4 km) from Aberdeen.

Fig. 109 and Keith Junction signal box appears neglected in this view. This is worrying, as no boxes from the GNoSR appear to be listed as of yet. The line from Elgin runs in past the box from behind the camera and loops out for a bit, before going to single track for Huntly, our next stop. The lines to the goods yard and the former line to Keith town are on the right. (September 2007).

81

Fig. 110. The bracket signal is to signal trains on to the loop line to access the goods yard and Keith & Dufftown Railway, although two track panels have been removed to actually stop trains running between NR and the preserved railway. The signal on the right is a platform starter and does not appear to be track circuited, which is unusual. Note how the ladder and hoop on the bracket signal are to the front of the signal. Chivas Regal distillery building is on the right. (September 2007).

Fig. 111. This is the view back along the platform towards Dufftown and includes the goods yard with shed. The original station buildings have found a private use. (September 2007).

Huntly (HT)

Date Built	GNoSR Type or Builder	No. of Levers or Panel	Ways of Working	Current Status (2015)	Listed Y/N
circa 1890	GNoS Type 2b+	40	TB	Active	N

Into Aberdeenshire now and Huntly used to have been known as Milton of Strathbogie – perhaps the name change was welcomed. Huntly is the home of the Gordon Highlanders regiment.

Huntly signal box is 40 miles and 43 chains (65.24 km) from Aberdeen.

Fig. 112. Huntly signal box used to be Huntly South, but it is solely in charge now. It did, however, need to be extended to fulfil its current task and that work is evident at the end nearest the camera. (September 2007).

83

Fig. 113. This is the view from a station platform at Huntly towards Aberdeen. The loop is bi-directionally signalled and the concrete huts on the left-hand side, at the entrance to the goods yard, are typical 1930s LNER small warehouses. They would be used to store grain or cattle feed, or indeed any goods that needed to be kept dry. The stone pillar by the concrete huts has lost its steam-age water tank on top for locomotive replenishment. The yellow marker post advises us that the end of the platform is 40¾ miles (65.6 km) from Aberdeen. (September 2007).

Fig. 114. At the other end of the station platform at Huntly, a Scotrail Class 150 DMU has the 'OFF' for Inverness. (September 2007).

Kennethmont (KN)

Date Built	GNoSR Type or Builder	No. of Levers or Panel	Ways of Working	Current Status (2015)	Listed Y/N
circa 1888	Railway Signalling Co. Hipped Roof design for GNoSR	20	TB/AB	Active	N

Kennethmont is regarded as a village belonging to Huntly, but it is more famous for the Ardmore distillery, which is right by the line. At the survey date the station building, goods sheds and other facilities were all disused, but surviving.

Kennethmont signal box is 32 miles and 71 chains (52.93 km) from Aberdeen.

Fig. 115. Kennethmont signal box is accompanied by an LNER concrete hut. The goods yard starts just where the camera is. Kennethmont is the start of the double-track Absolute Block section to Insch. (September 2007).

Fig. 116 is a view of the Ardmore distillery and its rail connections, as well as the way into the goods yard. The view is towards Huntly. (September 2007).

Fig. 117. This wooden station building was closed in 1968. The cream-coloured paint was an LNER colour in the earlier days of the company. Also present was a grounded LNER 10T box van, which had been in use as for storage, as well as many stone-built huts and goods offices that had not seen use for some years. (September 2007).

Fig. 118. The double track heads off towards Insch and Aberdeen. The double-track section is about 5 miles (8 km). Note the distinctive mile post informing us we are 32¾ miles (52.7 km) from Aberdeen. Also noteworthy is that the telephone/telegraph pole route is still in place. (September 2007).

Insch (IH)

Date Built	GNoSR Type or Builder	No. of Levers or Panel	Ways of Working	Current Status (2015)	Listed Y/N
circa 1886	GNoS Type 2a	20	AB/TB	Active	N

The village of Insch is dominated by the abandoned Dunnideer Castle atop a local hill.

Insch is a station and signal box that has survived the ravages of time far better than most. The station building, waiting shelter and water tower base all survive.

Insch signal box is 27 miles and 42 chains (44.3 km) from Aberdeen.

87

Fig. 119. Insch signal box is platform-mounted and was extended in 2000. Presumably, the line about a third along the front wall marks the spot; even so, it has been well done. (September 2007).

Fig. 120. The tower from Dunnideer Castle is on top of the hill in the background. The previously mentioned original features are almost all on view. The station building has a tablet of stone, which is inscribed '1880'. The view is from the station footbridge, looking towards Kennethmont and Inverness. Note that there are three rods coming out of the signal box for the two points on the layout. There is one for the refuge siding on the Down side towards Inverness. One lever operates a point and a trap point. There are two more levers for the junction point that sees the line single again, which are for the point and for a facing point lock. (September 2007).

Fig. 121 is the view from the station platform towards Aberdeen. The refuge siding is just about visible and the junction point is plainly so. Note the elevated ground disc for reversing into the siding and a similar device for driving out of the siding. Also noteworthy is the pole route, once again. (September 2007).

Inverurie (IE)

Date Built	GNoSR Type or Builder	No. of Levers or Panel	Ways of Working	Current Status (2015)	Listed Y/N
1902	GNoS Type 3b	30	TB	Active	N

Inverurie was most famous as being the home of the GNoSR railway locomotive works for sixty-four years, until its closure in 1969. It is now known mainly as a commuter base for the oil exploration workforce.

Inverurie signal box is 16 miles and 79 chains (27.34 km) from Aberdeen.

Fig. 122 and the signal box at Inverurie was used to busier times, but a number of sidings still survive here. At the survey date there were sidings for timber, lime and engineer's ballast, as well as a group of three loops used by English, Welsh and Scottish Railways (EWS). (September 2007).

Fig. 123 depicts some of the sidings on view, as well as the main and loop running lines to the right. The MGR hoppers appear to be out of use and these were progressively put out of work by the introduction of high-capacity bogie coal hopper wagons, which did not need the lineside 'Dalek' apparatus to activate the doors. The view is towards Insch and Inverness. The trackside marker post declares that we are 17 miles (27.36 km) from Aberdeen. (September 2007).

Fig. 124 shows the line towards Aberdeen at Inverurie station platform 1. This platform is known as the 'Main' and platform 2 as the 'Loop'. The pleasing platform canopy looks as though it has been cut back over the years. The station sees a total of thirty-two trains a day, which equates to an hourly service and yet only handles 500,000 passengers a year. (September 2007).

Dyce (DY)

Date Built	GNoSR Type or Builder	No. of Levers or Panel	Ways of Working	Current Status (2015)	Listed Y/N
circa 1880	GNoS Type 1	26 After 2007 Nx Panel	TB	Active	N

Dyce has historic Pictish origins but it is now regarded as a suburb of Aberdeen. It is also the site of Aberdeen airport and a great deal of oil industry activity.

Dyce signal box is 6 miles and 11 chains (9.88 km) from Aberdeen.

Fig. 125 illustrates Dyce signal box in a transitional phase, vying for the Sherpa Tensing endorsement. The bracket signal has a grey-posted colour light signal below it with a white cross – the universal symbol for 'Not in Use Yet'. (September 2007).

Fig. 126 is the view towards the granite city of Aberdeen and the loop arrangements. Another colour light signal can be seen on the right. (September 2007).

Fig. 127 is another view from the footbridge at Dyce station, this time looking towards Inverurie. Fittingly, the pinkish granite ballast is on view, which is so well known in Scotland and Aberdeen. (September 2007).

Clachnaharry (–)

Date Built	Highland Railway Type or Builder	No. of Levers or Panel	Ways of Working	Current Status (2015)	Listed Y/N
circa 1890	McKenzie & Holland Type 3 Highland Railway	4	Gate	Active	Y 'B'

Clachnaharry on the Highland Railway should more properly have been covered in a previous volume but it was missed out, so is included here.

It is appropriate that it is included here, however, as it is the opposite end of the Caledonian Canal to Banavie on the NBR. The box here performs a similar function to that at Banavie, but without the RETB component.

Clachnaharry is 1 mile 50 chains (2.62 km) from Inverness.

93

Fig. 128 shows Clachnaharry as a compact establishment that had originally been a block post out of Inverness. Smaller railways often relied on signalling contractors and McKenzie & Holland from Worcester had signal boxes all over Britain for various companies. (November 2015).

Fig. 129 shows the size of the Caledonian Canal and the bridge needed to cross it. The signal box controls the swing bridge and two colour light signals on the approach. The Caledonian Canal had been ambitiously built to carry the ocean-going ships of the day, so it is unusually broad for a canal in Britain (although canals on the continent of Europe are routinely as wide, if not wider). Note the locking rod between the tracks. There is also a catch (which resembles an up-scaled garden gate-type device) that locks the bridge, presumably when there are no trains running, as here. Obligingly, as with Banavie, there is a public footpath that takes you over the tracks. (November 2015).

Fig. 130 shows the four-lever frame at Clachnaharry signal box. The two red signal levers are 'OFF' as the signal box was not crewed at the survey date. The brown gate lock lever has two locking keys in it. The NEC Multisync monitor on the desk is for the Trust computer screen, which gives a real-time commentary on trains running between Inverness, Wick and Thurso. (November 2015).